# The School of Paris

In the captions dates in parentheses do not appear on the work.
In dimensions height precedes width.

Following page: HENRI MATISSE. French, 1869-1954. *Moroccan Garden,* 1912. Oil on canvas, 46 x 32¼". Purchased 1951.

It has been pointed out that when Matisse traveled to Tangier for the first time, in the winter of 1911-12, the excitement it inspired in him was not due to its exoticism, but to the new, purely visual responses it drew from him as an artist. Nevertheless, there is a quasi-Oriental languor in the way the three plump curves at the left meet the sinuous grace of the tree at the right to form a broad arabesque between them that dominates this picture. There is not a straight line in the canvas; the forms are as soft and lush as the colors, and over all hovers a sense of noonday heat and stillness. It is one of the three park or garden scenes done at the time, and the most stylized, abstract and flatly conceived of the group. Matisse was attracted to the brilliant colors and to the strange flora—such as the acanthus plant found here, which he had never seen outside of stone carvings on Corinthian capitals.

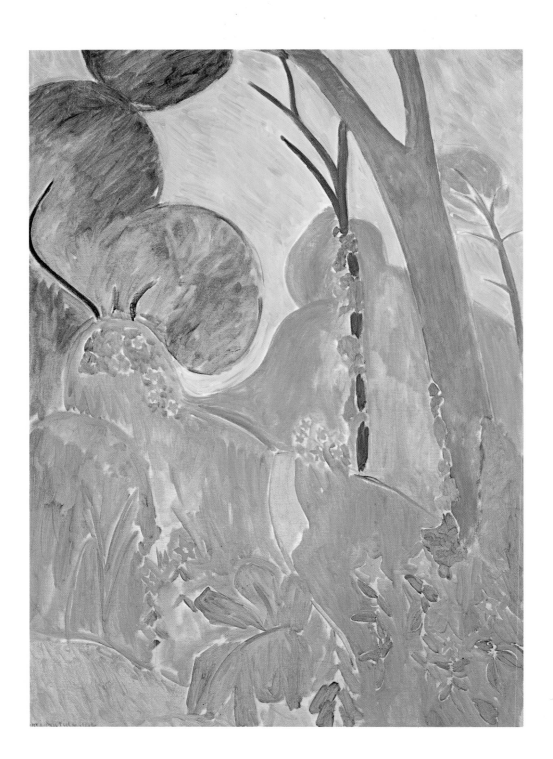

# The School of Paris

PAINTINGS FROM THE FLORENE MAY SCHOENBORN AND SAMUEL A. MARX COLLECTION

Preface by Alfred H. Barr, Jr.     Introduction by James Thrall Soby     Notes by Lucy R. Lippard

THE MUSEUM OF MODERN ART, NEW YORK in collaboration with The Art Institute of Chicago, City Art Museum of St. Louis, San Francisco Museum of Art, Museo de Arte Moderno, Mexico

Copyright © 1965 by The Museum of Modern Art
Second printing 1978
All rights reserved
Library of Congress Catalog Card Number 65-25727
Paperbound ISBN 0-87070-575-X
Designed by Joseph Bourke Del Valle
Printed by Lebanon Valley Offset Company, Inc., Annville, Pa.

The Museum of Modern Art
11 West 53 Street
New York, N.Y. 10019
Printed in the United States of America

## PREFACE

To visit the apartment of Sam and Florene Marx was a unique experience even for one who had been inspecting private collections of modern art with more or less professional scrutiny for over forty years. Neither in Chicago nor more recently in New York were the Marx apartments large—or did they merely seem modest in size because the *objets d'art* were so many and the paintings so big? Everywhere, in the vitrines, on shelves, pedestals and table tops, in corners were things to look at—objects superbly chosen with knowledge and discrimination. Sam Marx was an architect and a distinguished designer of interiors but his apartment did not at all suffer from the cautious restraint of conventional good taste. Variety, a spirit of enthusiasm and rich profusion were there; profusion, yes, but magically, without clutter. And then one raised one's eyes: the minor pleasures of the foreground faded and there on the walls were the pictures.

In several ways Florene and Sam Marx were not pioneers when, together, they began to collect paintings, some twenty-five years ago. They could, and perhaps did, look back to those redoubtable San Francisco expatriates Leo and Gertrude and Sarah Stein, who as early as 1905 had felt that Matisse and Picasso would be the two great new masters of the twentieth century. But the Marxes were not avant garde; only once did they buy a canvas while the paint was still wet. Nor did they venture outside the well-known painters of the School of Paris. Their courage—and courage they had—was

shown in selecting what they felt to be best without regard to the conventional proprieties. They did not prudently shun paintings that were in size and demeanor "unsuitable for the home," paintings that rudely asserted themselves in company, that tended to diminish the scale of living rooms or, one might add, the scale of owners and their guests.

This is not to say that all the Marx pictures are heavy artillery. Some are small and easily domesticated and some of the best large ones—the Braque *Yellow Table-cloth* and the wonderful Bonnard—are gentle, charming and serene. But what gives the Marx collection its character is the dozen or so magnificent paintings that even ten years ago would have seemed, to most collectors, too big, too aggressive and too strong to live with: Léger's *Woman with Cat*, La Fresnaye's *Artillery* and Dubuffet's *Building Facades*; Picasso's *Woman's Head* and cubist *Woman with Pears*, his monstrous blue surrealist *Woman by the Sea* and his *Girl Reading*; and, finally, the heroic Matisses of the great years 1911 to 1916: the largest and most abstract of the seven goldfish paintings, de Heem's grandiose, seventeenth-century still life exploding into color, the austere *Woman on a High Stool* (a favorite of Florene Marx) and the culminatory *Moroccans*.

Perhaps because it was so big and uncompromisingly powerful, Matisse had kept *The Moroccans* for thirty-five years when in 1951 The Museum of Modern Art borrowed it a second time for a Matisse retrospective.

The Marxes saw it and insisted on buying it to keep for awhile before giving it to the Museum. In Chicago *The Moroccans* took a dominating place in the Marx dining room where previously Picasso and Matisse had engaged in even competition. Fortunately for the Museum, the New York apartment was somewhat smaller so that, thanks to the generous Marxes, *The Moroccans* now more than holds its own in the Museum's Matisse gallery.

Now for the first time the paintings, small as well as large, in the Sam and Florene Marx collection (including works given to museums) are to be shown publicly in The Museum of Modern Art and then in The Art Institute of Chicago, the City Art Museum of St. Louis, the San Francisco Museum of Art and the Museo de Arte Moderno in Mexico City. Florene Marx, now Mrs. Wolfgang Schoenborn, with the gracious agreement of her husband, has made these exhibitions possible. Her fellow Trustees of The Museum of Modern Art wish to thank Mrs. Schoenborn for her public-spirited generosity in lending the collection to the Museum so that it may be shown not only in New York but in other museums across the continent.

Alfred H. Barr, Jr.
Director of the Museum Collections

Following page: HENRI MATISSE. French, 1869-1954. *Woman on a High Stool* (1913-14). Oil on canvas, 57⅞ x 37⅝". Purchased 1958. The Museum of Modern Art, New York. Gift of Mr. and Mrs. Samuel A. Marx, the latter retaining life interest.

In the gray cold of a Parisian winter, Matisse painted this austere, simplified figure which is diametrically opposed to the colorful, sensuous freedom of *Moroccan Garden* (frontispiece). Warmth and hedonism have been replaced by a rigorous linear style and sober gray, near-monochrome palette. Strong line defines the massive columnar weight of the figure, tapering from heavy stool to solid, slightly rounded body to oval head on a straight neck. An equally heavy but less expressive line is used to describe the other two objects. The composition is reduced to a minimum; not an extraneous detail mars the ascetic restraint. The vase painting on the wall, by Matisse's then teen-aged son, Pierre, repeats the figure, in a symmetrical placement as well as in form. (*Woman on a High Stool* served a similar function two years later in the great *Piano Lesson* in The Museum of Modern Art.) A brief transition between the strict verticality of these two elements and the table's horizontal is effected by the sheet of paper which acts as a diagonal *repoussoir* and in turn duplicates the angle at which the stool is set.

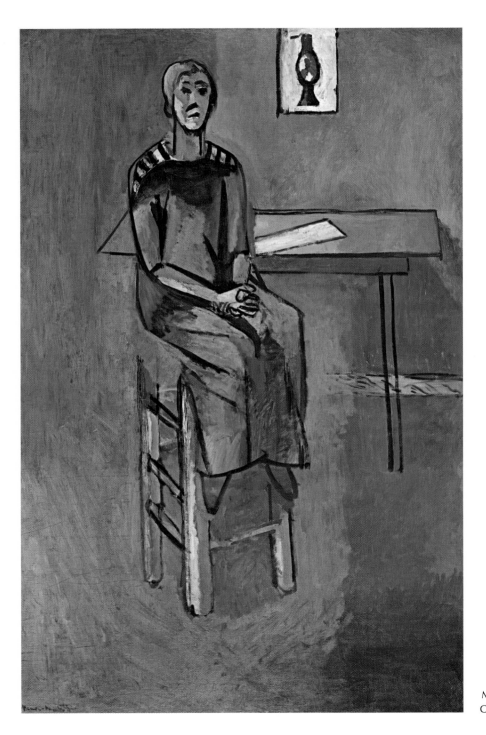

MATISSE. *Woman on a High Stool* (1913-14).
Oil on canvas, 57⅞ x 37⅝". See note, page 5.

# INTRODUCTION

The works of art in this collection have been chosen with the rapt concentration of diamond cutters, anxious to discover and preserve the ultimate facets of beauty in an already precious substance. No imperfections, however slight, have been tolerated, nor have flaws in the qualitative character of the gems themselves. The result is a collection of such authority that it would be difficult to think of its rival among private collections of modern art.

The collection has been kept small deliberately—and this in an era when other inspired American collectors have preferred to buy in number. The process of its distillation and refinement has been continuous. I remember once walking awe-struck through the Chicago apartment where Florene and the late Samuel A. Marx lived and where most of these paintings were hung. The supply of meaningful superlatives in our language is astonishingly limited. I had about run through it in commenting on the pictures when Sam Marx said: "I wish there were fewer and better paintings here by the same artists." The first part of his wish could have been managed, of course; the second part with few exceptions was impossible. I said so and Sam replied: "That's the trouble. There's nothing here now that Florene and I would like to exchange."

All the sculptures in the collection have been omitted from the present exhibition for the simple reason that transporting them would have been difficult and some of the finest are fragile. The word "all" immediately strikes a discordant note. It implies that the sculptures are numerous. They are not. As in the case of the paintings, a devoutly selective procedure has been followed. The collection's founders never shared the current passion, sometimes genuine and deep, sometimes vainglorious, for discovering major artists in their embryonic state. Instead their aim was to buy and cherish the truly exalted works of painters and sculptors of international repute. Their aim has not been easy to achieve. It has won the collection a world-wide respect.

Among such treasures as the paintings in this exhibition, it is perhaps foolhardy to single out a transcendent work. Yet few, I think, would deny that Matisse's *The Moroccans* (page 15) is a climactic picture in the career of a twentieth-century artist whom only Picasso has been able to rival. In compositional daring and vigor of color *The Moroccans* is surely one of the greatest paintings of our time. It is as abstract in the sense of defying instant legibility as the pictures by the early Kandinsky, the cubists and other patriarchs of what is by now a venerable anti-realist tradition. It does not so much evoke space by linear definition and modeling as it awakens it through a series of tonal vibrations. It does so without straining credulity or reaching for effect; it is under reckless yet unerring control from beginning to end. It forcefully summarizes the masterful discipline which guided this artist's spontaneity and freshness. The almost scholastic research which underlies its lyric outburst is revealed by comparing it with the *Variation on a Still Life by de Heem* of the same period (page 13).

A second magnificent Matisse is the slightly earlier *Woman on a High Stool* (page 6). Here the stern, grim elongation of the figure contrasts markedly with the rococo voluptuousness of the painter's later odalisques. The *Goldfish* (page 10) of the following year (1915-16) is no less remarkable in its bold and haunting simplifications of form. And among the less ambitious paintings by Matisse, none better exemplifies his ability to make sketchiness an evocative and dignified pictorial device than his *Moroccan Garden* (frontispiece), executed as early as 1912.

I think it is perhaps the superb group of Matisses which best typifies a fundamental of the collectors' taste. In art they disliked—or at any rate were indifferent to—the tame and the pretty. When they had made up their minds about the validity of a given artist, they sought him full strength, without regard for seductiveness, fashion or ready availability. The "availability" of masterworks of modern art might seem to have been a minor problem in 1939, when this collection began to be formed. But even then the number of courageous private collectors was growing rapidly and some important museums here and abroad had entered the field of advanced contemporary art. The outbreak of

World War II had sealed off the European markets and almost nothing available of top quality crossed the Atlantic for six years. To start building a great collection against such odds of scarcity required patience and alertness to an exceptional degree. These were virtues Sam and Florene Marx combined with rare visual sensitivity. They pored over books and magazines, occasionally consulted museum curators—and in the end made up their own minds.

The vigor of taste which sustains the collection at its very high level is nearly as apparent in the case of Picasso as in that of Matisse. It is true that elegiac compassion is found in the former's *Head of a Peasant* of 1906 (page 19) and tenderness in the much later *Head of a Boy* (page 27). But we should remember that mercy for the old and adoration of the young have been constants of Picasso's volatile temperament and that he has utilized both emotional extremes without surrendering dignity to sentiment, certainly not in the examples here shown. Even so, it is Picasso at full-stop volume who dominates this selection of his works. In this connection it is worth noting that the *Woman Combing her Hair* (page 18) provides a relatively strident foil to the *Head of a Peasant,* already mentioned, as does the monumental *Bust of a Woman* (page 16). Late in 1907, after the miracle of the world-famous *Les Demoiselles d'Avignon,* Picasso took another precipitous step forward and plunged into his short-lived but extremely important "Negro" period. By comparison with what he had done before a new, almost convulsive spirit is apparent and it cut off forever Picasso's inheritance from *fin-de-siècle* Parisian art and from certain rather sweet variants on Spanish Mannerism by which he had been seduced in youth during his Blue and Rose periods. He began to walk now with a more ferocious pride, like his beloved Minotaur thrashing in its cave. The *Woman's Head* (page 17) is a condensed and severe example of Picasso's style during the year 1907. The picture's impact as a tribal icon is softened somewhat in the slightly later *Bust of a Man* (page 17). By 1909, when the *Woman with Pears* was painted (page 21), the artist was thoroughly engrossed in the revolutionary cubist esthetic which he and Braque had developed the year before.

Cubism's austere reticence as to color and texture underwent a gradual enrichment. By the time of World War I Picasso was creating such resplendent works as the *Guitar over Fireplace* (page 22) wherein cubism's earlier sobriety was relaxed in favor of encrusted and speckled surfaces and aggressive tonal contrasts. In the mid-1920s the artist brought to a conclusion a series of unashamedly handsome still lifes, among them the fine *Still Life with Plaster Arm* (page 23). Most of the paintings in the series are relatively straightforward and have few if any psychological overtones. But in one passage at least, the picture just mentioned provides a prophetic exception. There is something distraught about the way the painter intensifies the gesture of the plaster hand clutching the spear shaft, as though Picasso were tiring of unrelieved sensual charm.

This was indeed the case. Two years later the influence of surrealism's clamorous uprising began to be unmistakable. If Picasso was too powerful and established an artist to become a surrealist in the official sense, there can be little doubt that he was affected by the new group's emphasis on the unrestrained and frequently tumultuous imagery suggested by the subconscious mind. The *Head* of 1927 (page 25), with its relationship to the scrawls of troubled children, illustrates Picasso's respectful if brief absorption in the vast terrain of psychological fantasy and aberration opened up by Freud and his disciples.

From such a deliberately flat graffito Picasso turned to extreme roundness of form, as in the *Woman by the Sea* (page 27). Beginning with a series of small pictures executed at Dinard during the summer of 1928, he became interested in biomorphic and hallucinatory structures, conceived on a much larger scale and closely allied to sculpture. Here it must be noted that Picasso's extreme changeability cannot adequately be explained in formalistic terms of dimension or style. It includes drastic shifts in mood. From the meditative *Girl Reading* of 1934 (page 28) he was easily capable of moving on to the playful wit of the *Woman in Armchair,* its distortions both compulsive and laughable.

Picasso's comrade in the evolution of cubism, Georges Braque, is represented in the exhibition by six paintings. Their choice obviously was guided by the

collectors' recurrent emphasis on strength, for none of them descends to the decorative virtuosity toward which Braque's talent sometimes led him. They are rich and noble works and *The Mantelpiece,* the *Yellow Tablecloth,* the *Woman at an Easel* and *The Studio* (pages 32-35) are among the finest pictures of Braque's long career. To Picasso's headlong passion as an artist Braque opposed and brought to a very high level *le bon goût* in the best sense of the term. Whereas the former's art is often restless, the latter's is calm, thoughtful and intensely professional.

Two other ranking members of the cubist group—Gris and Léger—are represented by two estimable works apiece. Unlike Picasso, who without strain or betrayal could court elegance and exploit the uncouth, Juan Gris was single-minded in purpose and faith. His vision was crystal clear, his goal perfection. In such early works as the *Still Life with Playing Cards* (page 36) and even more unanswerably in his collages of the following year (page 38) he attained a purity which was neither delicate nor cold but inspired and fresh. His colleague, Fernand Léger, seems to me (perhaps unreasonably) to have reached more personal ground when he moved on from cubism to those bold reflections on our mechanized era typified in *The City* (page 37) and the swollen tubular forms of the *Woman with Cat* (page 39).

Roger de La Fresnaye's estimable function was to combine the angular structure of cubism with traditional French relish in color, as though he kept Delacroix in mind as well as Cézanne. The beginnings of his achievement may be discerned in his *Artillery* of 1911 (page 40), even though the picture is sombre by comparison with the works he produced two years later. De La Fresnaye was French to his fingertips. So was his elder, Raoul Dufy, who never endorsed cubism's principles but who in 1916 created the memorable *Mozart's House in Salzburg* (page 41), using a swift calligraphy which later declined into a fashionable formula. The taste of those who built this collection was far too erudite to be contained by dogmatic faith in visual revolution for its own sake. Thus they also bought and cherished one of Pierre Bonnard's greatest works, the *Nude in Bathroom* (page 42). They realized fully that Bonnard was not merely a belated impressionist but was, on the contrary, a consummate master of opalescent color and compositional audacity. And they admired Rouault before repetition reduced his anguished screams to a mumble; they liked Soutine in his giddy prime (pages 50-53, page 55).

Sam and Florene Marx were no believers in national superiority in the arts. However deep their interest in French-born artists, they acquired besides the Picassos a first-rate picture by the Italian Modigliani (page 43) and one of the four very large works done in his youth by de Chirico, Modigliani's compatriot and the chief progenitor of the surrealist movement in painting (page 45).

For Joan Miró they felt a particular affection. They saw that Miró, like his elder countryman Picasso, matured early as an artist. They acquired his fine *Portrait of E. C. Ricart* (1917) as well as one of the best works from his superb series of "Dutch Interiors," based on postcards of pictures by the Dutch Little Masters which Miró had brought home from a trip to Holland in 1928 (pages 46 and 48). They owned two later and more impulsive oils by the Spanish artist. And from the plethora of over-refined painters in postwar Paris they singled out the hardy and immensely gifted Jean Dubuffet, a bitter opponent of art for art's sake (page 54).

The pictures here shown form what is assuredly one of the most remarkable and heartening private collections of modern painting ever assembled. Its public exhibition will confirm what friends of these collectors have long known—that such warm and uncompromising taste can create its own masterwork.

James Thrall Soby

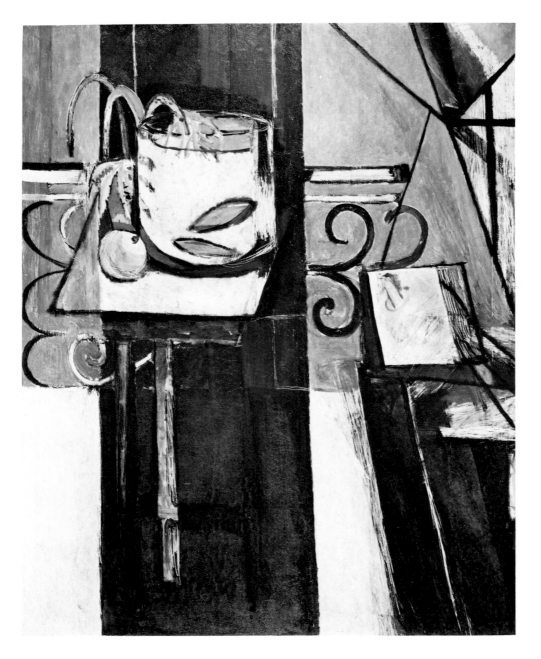

MATISSE. *Goldfish* (1915-16). Oil on canvas, 57¾ x 44¼". See note, page 12.

Opposite: MATISSE. *Apples* (1916). Oil on canvas, 46 x 35". See note, page 12.

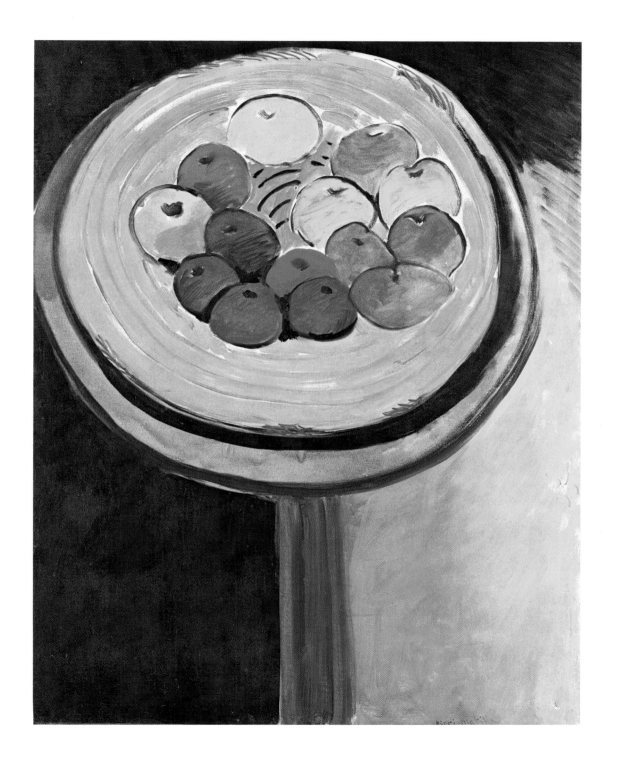

MATISSE. *Goldfish* (1915-16). Oil on canvas, 57¾ x 44¼". Purchased 1948. The Museum of Modern Art, New York. Gift of Mr. and Mrs. Samuel A. Marx, the latter retaining life interest.

More than a touch of cubism, to which Matisse was attracted late in its great period, can be discerned in this still life, but if shifting space, angled planes, the linear network at the right and the up-tilted table with its "transparent" section reflect the prevailing mode of the times, the implacable black vertical, the ornamental curls of the ironwork and the touches of brilliant color and powerful but free line are utterly personal. This is the last and least realistic of a group of six *Goldfish* interiors; it is centered on the bold opposition of black and pale, lyrical blue, with the fruit, the fish and the plant providing colorful focusing points, faintly echoed in the maroon and green shadows on the table legs and the patches of orange and reddish brown at the right.

MATISSE. *Apples* (1916). Oil on canvas, 46 x 35". Purchased 1940. The Art Institute of Chicago. Gift of Mr. and Mrs. Samuel A. Marx.

A far more simple and radical rendition of the verticality and single object found in *Goldfish* (page 10) appears in the almost symmetrical *Apples*. The theme might be said to be roundness, although no form is absolutely circular. The full volumes of the fruits complement the flat roundness of the table top. Opposed to this spherical dominance, however, is the more rigorous quasi-striped effect of the ground—from blackest of black shadows on one side to a swathe of yellow light on the other. The heavy contour line of the lower arc of the table endows the lower half of the canvas with a weight that balances the concentration of formal interest in the upper half. Vestiges of the cubist concept of double viewpoint are retained, since the table leg is seen from the side, its top and the apples from above.

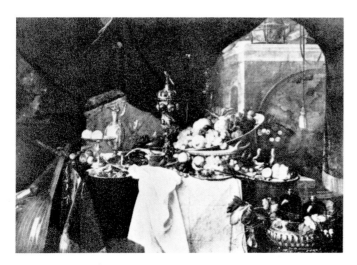

JAN DAVIDSZ de HEEM. Dutch, 1606?-c.1684. *The Dessert.* Antwerp, 1640. Oil on canvas, 58⅝ x 80". Paris, The Louvre Museum.

Opposite: MATISSE. *Variation on a Still Life by de Heem* (1915, 1916 or 1917). Oil on canvas, 71¼ x 87". Purchased 1940. The Museum of Modern Art, New York. Gift of Mr. and Mrs. Samuel A. Marx, the latter retaining life interest.

This is the second time in which Matisse utilized *Dessert* by Jan Davidsz de Heem (left), a seventeenth-century still life in the Louvre. The first version—a relatively faithful academic copy—dates from the mid-1890's. Returning to the subject some twenty years later, he found it provided all the favorite cubist props for what is his major work in that idiom. Fruit, glasses, pitcher, fruit dish, bottles, musical instrument and architectural planes are arranged within the traditional shallow-spaced grid, in a composition closer to Cézanne and Juan Gris than to Picasso and Braque. Matisse has transformed the horizontal composition by cutting it with a strong black vertical and stressing a pillar at the left rather than the broader spreading arch at the right. The color too is a combination of cubist monochrome—concentrated in the more detailed right side—and Matisse's own ebullient palette—most conspicuous in the landscape seen through the window, which is less rigidly constructed than the rest.

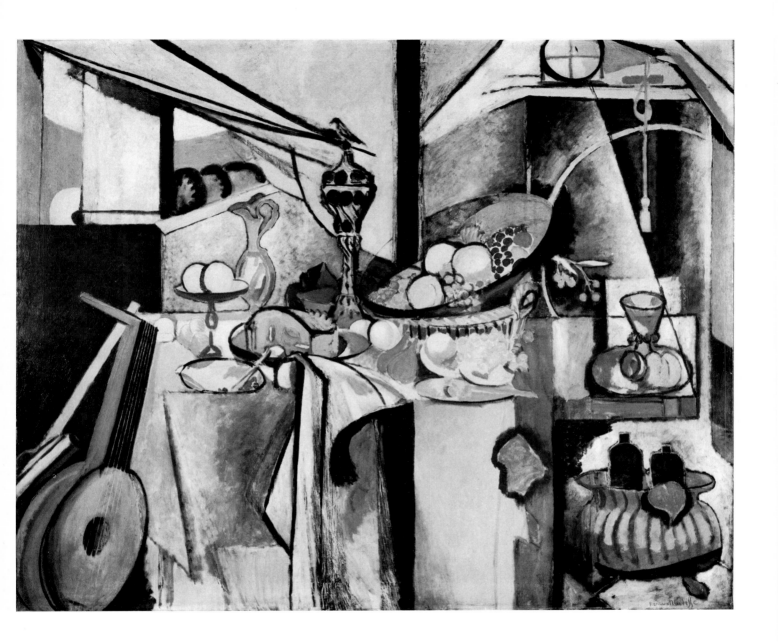

13

MATISSE. *The Moroccans* (1916). Oil on canvas, 71⅜ x 110". Purchased 1951. The Museum of Modern Art, New York. Gift of Mr. and Mrs. Samuel A. Marx.

Painted from memory, this monumental canvas distilled the essence of Matisse's two Moroccan sojourns. "My choice of colors is based on the very nature of each experience," Matisse wrote. Tangier might well be such pinks, terra cottas, yellow, blue and green against a rich black field. A tour de force synthesizing preconceived, geometrical principles and intuitive idiosyncratic color and form, the painting consists of three clearly separated areas: the mosque dome over the terrace with its bunch of blue and white striped flowers, the four melons with bulging leaves on a checkerboard pavement (these have also been read as praying figures), and the extremely abstract worshippers at the right. Analogous circular motifs are found in each area, but otherwise the shapes are varied between inanimate walls, organic fruit and the human body. The tone and rhythms of each are distinct, but they interact in terms of form, color and meaning to animate the black time-space dividing them.

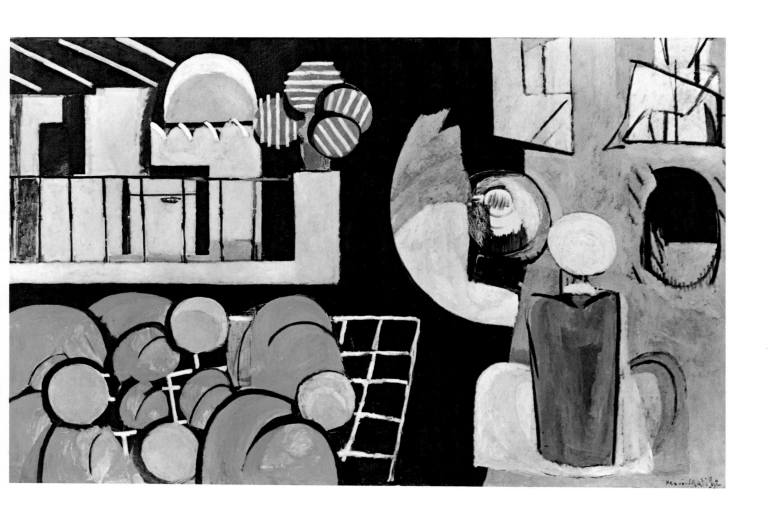

15

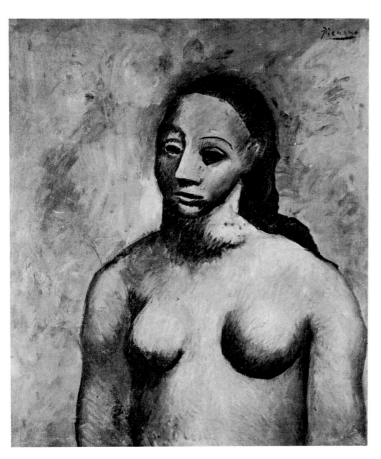

PABLO PICASSO. Spanish, 1881–1973. Lived in France. *Bust of a Woman* (1906). Oil on canvas, 31½ x 25¼". Purchased 1955. The Art Institute of Chicago. Gift of Mr. and Mrs. Samuel A. Marx.

During 1906, Picasso was gradually assimilating the influences of Cézanne and of the chunky pre-Roman Iberian sculptures newly arrived at the Louvre. *Bust of a Woman* is completely sculptural, although placed just off-center in order to activate the two-dimensional picture space. It has a crude, but not yet aggressive strength. The egg-shaped head, with its geometrically simplified features, is expressionless. Picasso had abandoned the charm and somewhat illustrative qualities of his earlier work to explore the vital formal and emotional potentials of primitive cultures. The way was now paved for the birth of cubism and for one of the major monuments of modern art. In 1907, *Les Demoiselles d'Avignon* dynamically shattered all vestiges of classical calm and solid volumes.

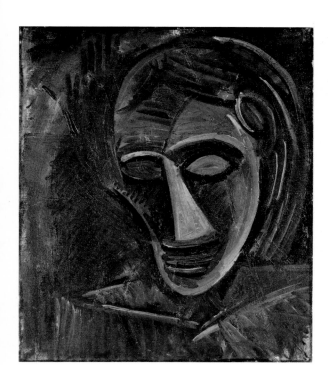

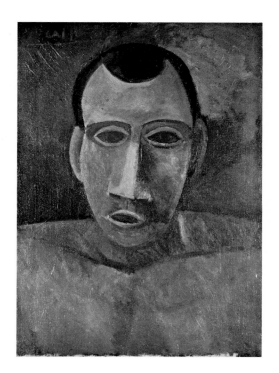

PICASSO. *Woman's Head* (1907). Oil on canvas, 28⅞ x 23¾". Purchased 1951.

Picasso says that he did not see any African sculpture until 1907, although Vlaminck and others had been collecting it since 1904. Nevertheless, by the time he was completing *Les Demoiselles d'Avignon,* he had been profoundly impressed by the intensity and lack of visible reality found in sculpture and masks from the French Congo and the Ivory Coast. One of the numerous studies for and after *Les Demoiselles,* this head was painted while the larger canvas was still in process though it recalls the upper right figure. The direct resemblance to African masks is conspicuous, but the painting is also notable for its extremely expressionist strokes, its muted palette of greens, olives and ochres (increasingly prevalent in the next few years), and its disregard of all but the most salient facial features, distorted for maximum emotive power.

PICASSO. *Bust of a Man* (autumn, 1908). Oil on canvas, 24⅜ x 17⅛". Purchased 1955.

By 1908 Picasso was returning once again to a more three-dimensional and sculptural form, but instead of repeating the fully rounded naturalistic volumes of 1906 found in *Woman Combing her Hair* and *Bust of a Woman* (pages 18 and 16), he employed the stylization of the "Negro" period to produce angular, faceted planes, suggestive rather than descriptive of mass. Eyes and mouth are identically bordered almond shapes, like those in African art, but the violent dislocation of *Les Demoiselles d'Avignon* has given way to a calmer and more monumental concept.

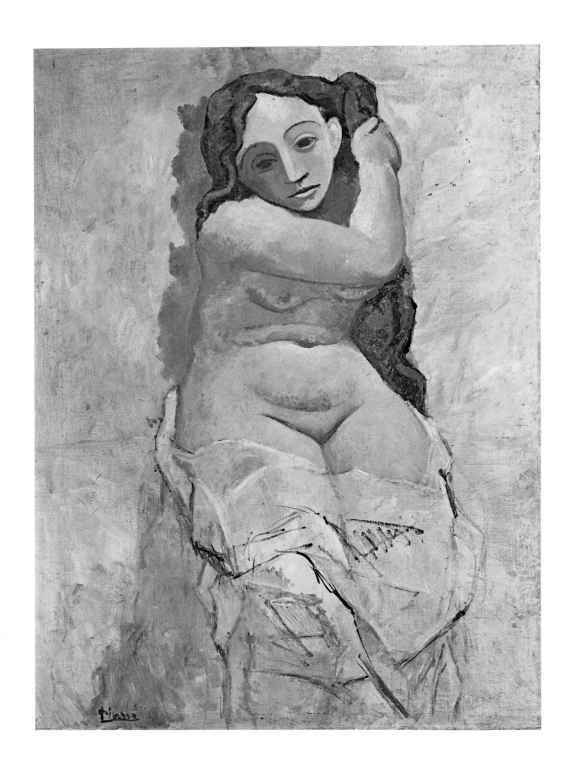

Opposite: PICASSO. *Woman Combing her Hair* (1906). Oil on canvas, 49⅝ x 35¾". Purchased 1939.

This represents a step toward a sculptural rather than pictorial conception of the figure; there is also a bronze version of the subject. Essentially a transitional painting, it is progressively less advanced in style from top to bottom. The head achieves a new severity, rendered in simple geometrical terms; the torso consists of firmly modeled volumes in a more realistic idiom. Then, at the thighs, the figure is abruptly dematerialized by a wispy garment covering the legs, which are barely defined within the cloud of pinks and grays and rapid line. The upper area is further solidified by the rectangular frame of hair and dark shadow. The new interest in compact, massive form notwithstanding, Picasso still presented his subject within an aura of grace and melancholy.

PICASSO. *Head of a Peasant* (1906). Oil on canvas, 15⅞ x 17¾". Purchased 1953.

Picasso spent the summer of 1906 in Gosol, in the Spanish Pyrenees, where he culminated his classical Blue and Rose periods with a group of figure studies, many of which depicted the peasants of the region. He did several drawings of this old man with his sad but stoic expression. Despite the gentle coloring and linear technique, the painting has a certain strength and awkwardness that herald the break with traditional notions of beauty and modes of portraiture which was to transform Picasso's art. Conventional character study and the pathos of old age were soon to be replaced by more impersonal themes, and the lyrical, often sentimental style in which Picasso had been working since the turn of the century was to give way to a stronger, less graphic manner.

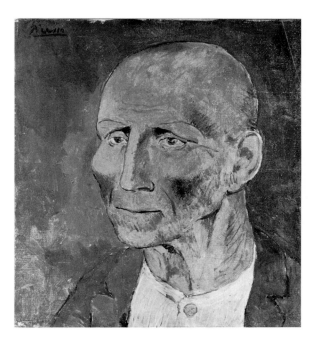

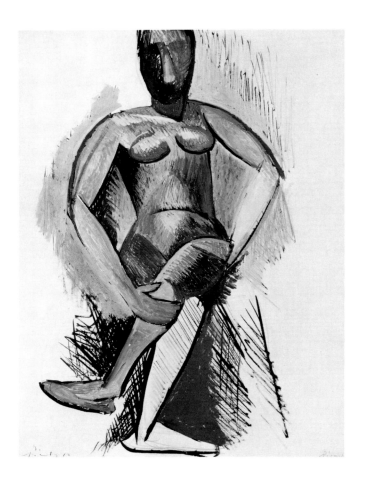

PICASSO. *Seated Nude* (summer, 1909). Gouache on illustration board, 24¾ x 19". Purchased 1944. The Art Institute of Chicago. Gift of Mr. and Mrs. Samuel A. Marx.

In 1909, Picasso was still exploring the possibilities of the African style initiated two years earlier. This sketch of a seated figure is less brusquely dislocated than the 1907 head, but more so than that of 1908 (page 17). Emotional intensity is diminished in favor of experimentation with combinations of flat and modeled, drawn and painted form.

Opposite: PICASSO. *Woman with Pears* (summer, 1909). Oil on canvas, 36¼ x 28⅞". Purchased 1955.

Picasso spent the summer of 1909 in Horta de Ebro, where he expanded Cézanne's geometrically structured forms into a new and more intellectual style based on a rapidly shifting viewpoint. "I paint objects as I think them," said Picasso, "not as I see them." In analytical cubism, the known properties of an object, as well as those seen at a given moment or from a given vantage point, are incorporated into a new whole by means of homogeneity of form and color. All the small, sharp elements are alike and overlapping; the palette is reduced to greens, grays and browns that cross the boundaries of the splintered forms rather than describing them singly. Nevertheless, head and still life are still sculpturally self-contained and easily distinguishable from each other. Later the underlying naturalism would be submerged in a field of fragmented planes with points of departure in recognizable form visible only at intervals. There is also a bronze of this head, but it reflects the faceted painting style, whereas the reverse was true in 1906 (see *Woman Combing her Hair*, page 18).

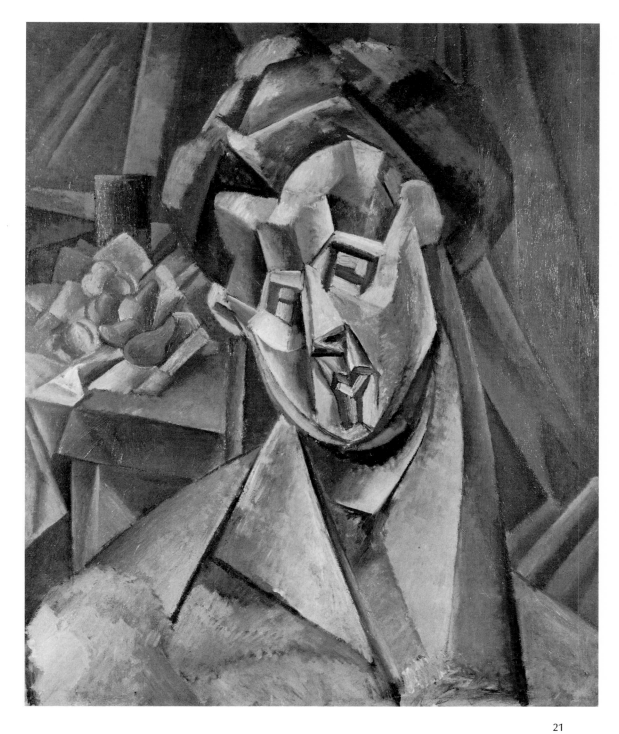

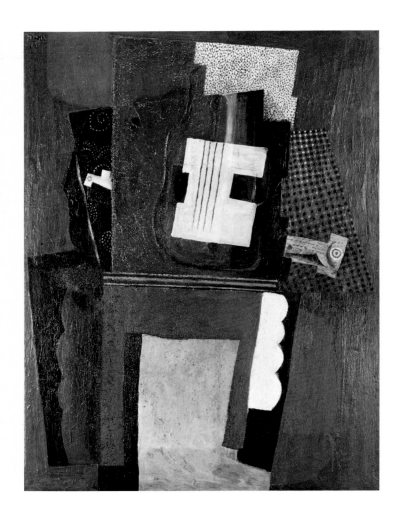

PICASSO. *Guitar over Fireplace*, 1915. Oil on canvas, 51¼ x 38¼". Purchased 1944.

By 1915 Picasso had introduced synthetic cubism, which takes its name from the invented forms suggested by objects but not directly abstracted from them, and therefore "artificial." It was enriched by bright colors, impasto textures and decorative patterns. Here Picasso mixed sand with the paint in places, built up relief edges (the guitar form in the center), simulated wood grain (right), punctured the paint (upper left), dotted it with a pointillist spray of color and generally added a tactile quality not found in the analytical period. Two canvas rectangles have been glued onto the center, perhaps to correct the composition, perhaps to provide further surface interest. The angular interpenetrating planes are broad and assured, so that the patterned areas provide highlights in the composition rather than merely prettify it. All depth is denied except for the minuscule amount of space implicit in the overlapping forms and in the known sense of the objects as they exist in reality.

Opposite: PICASSO. *Still Life with Plaster Arm*, 1925. Oil on canvas, 38½ x 51¼". Purchased 1953.

Ten years after *Guitar over Fireplace*, Picasso's cubism had softened and mellowed into curvilinear silhouettes. Compact, but free, rearranged, but not distorted, this still life is a monumental example of the type. The brilliant red of the tablecloth is more than a ground; it is the major formal element, an integral field of light against which the cut-out curve of mandolin, fruit and bowl, the angular book and table and flowing rococo shape of the plaster arm stand out in reflected clarity. The cool gray-green of the fruit is the sole tonal contrast within the rich color scheme, and the roughly brushed line of the mandolin strings provides just the masterful note of spontaneity and imprecision necessary to keep the painting from becoming too "perfect."

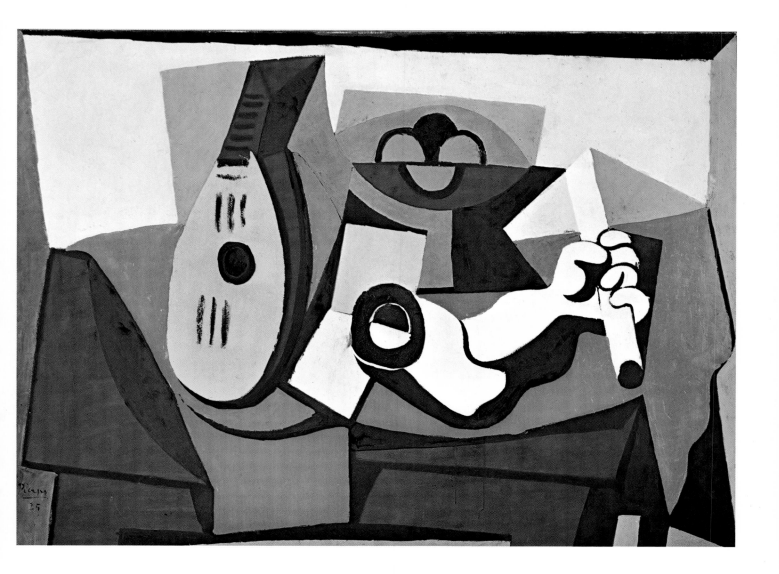

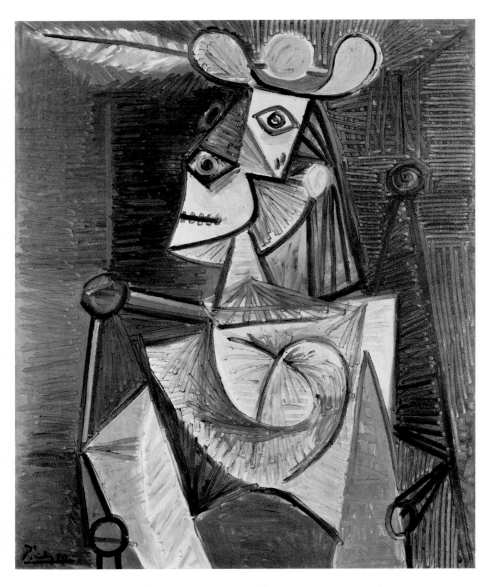

PICASSO. *Woman in Armchair* (summer, 1941). Oil on canvas, 36¼ x 28⅞". See note, page 26.

Opposite: PICASSO. *Head* (1927). Oil and plaster on canvas, 39¼ x 31¾". See note, page 26.

24

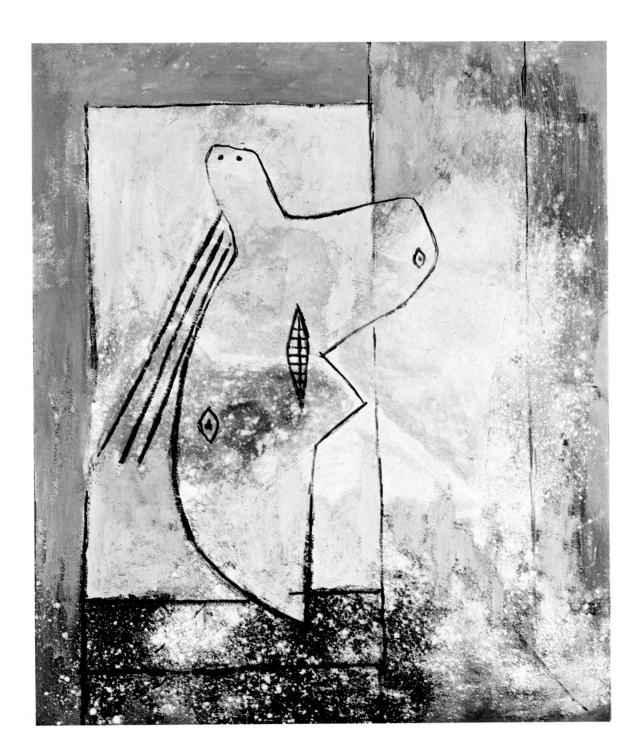

PICASSO. *Woman in Armchair* (summer, 1941). Oil on canvas, 36¼ x 28⅞". Purchased 1950.

Painted in July, 1941, when Paris was occupied by the Nazis, this portrait reflects the prevailing mood of despair and desperation in its brutal angles, roughly scraped striations that cover the surface, and hot color—red against magenta and browns. Both technique and emotional impact resemble the African head of 1907 (page 17) and the double image (eye as nose, armchair as arms and hands) resembles the 1927 *Head* (page 25). But this is also psychological portraiture at its best. It probably portrays Dora Maar—a photographer and artist in her own right, and a sharp, forceful personality. Despite the exaggeration of natural form, the sitter's character is effectively described by the erect pose and by the head, held back in a gesture at once gay, belligerent, and vulnerable. With her bared teeth and rolling eyes, the woman can be seen more generally as a primitive deity, a disquieting, even fearsome image whose brutality and energetic execution call to mind Willem de Kooning's famous *Women* of a decade later.

PICASSO. *Head* (1927). Oil and plaster on canvas, 39¼ x 31¾". Purchased 1951. The Art Institute of Chicago. Gift of Mr. and Mrs. Samuel A. Marx.

Surrealism was officially born in 1924, and Picasso had been casually associated with its adherents for some time. However, it was only around 1927 that he was drawn to its techniques in such visual puns as this face-figure, where head doubles as nose, nostrils as eyes, chin as arm, mouth as sex, brow as legs, and so on. Both metaphoric and metamorphic, the central form can also be interpreted in several other ways within the basically double image. If it is seen as a full-length figure, the upper protrusions can be read interchangeably as head or arms, and while the three lines at left remain hair, they change positions in each new configuration. Fundamentally this is a variant on the cubist practice of portraying a head in simultaneous front face and profile, and the shallow rectilinear ground is still vaguely cubist, but surrealism supplied the impetus for a freer, more irrational and spontaneous dislocation of that eminently rational concept.

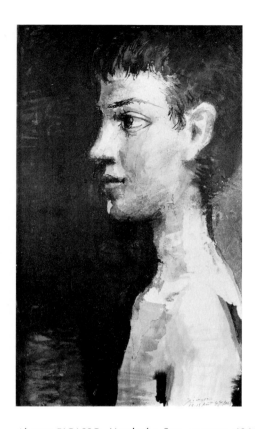

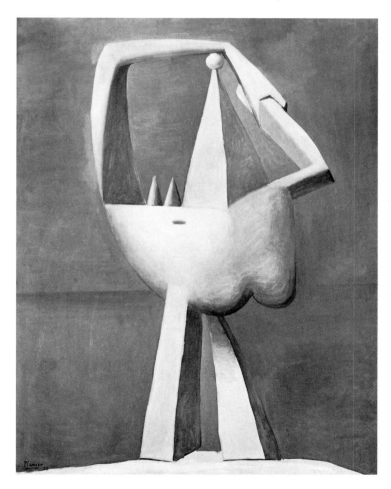

Below: PICASSO. *Woman by the Sea*, 1929. Oil on canvas, 51 x 38¼". Purchased 1952.

This standing bather, another product of Picasso's periodic preoccupation with sculptural form against a flat backdrop, is related to the more exotic "bone" paintings of the same year, as well as to surrealism's distorted quasi-illusionism. There is also an architectural quality in its geometrical solidity—a witty contrast to the robustly organic buttock-breast forms at the right. The grisaille figure is subtly touched by warm ochre tints on the right foot and upper left arm, as though a statue were slowly coming to life.

Above: PICASSO. *Head of a Boy*, summer, 1944. Gouache (brush and ink and wash), 19¾ x 11¼" (sight). Purchased 1951.

This is one of four nearly identical drawings of a young boy which were made within three days in August 1944—a period of great tension, just before the liberation of Paris. Picasso has explained his brief return to a romantic realism at that point by saying: "A more disciplined art, less unconstrained freedom in a time like this is the artist's defense and guard." Aside from its delicate but rapid execution, this elongated head of a solemn and beautiful child is very close to the sensitive lyricism of the Blue period, some forty years before. Thus Picasso as a cubist, a representational painter, an expert draughtsman, has remained constant to the prime directions of his art throughout the extraordinary variety of his life-work, a fascinating cross-section of which is presented by the fourteen paintings in this collection.

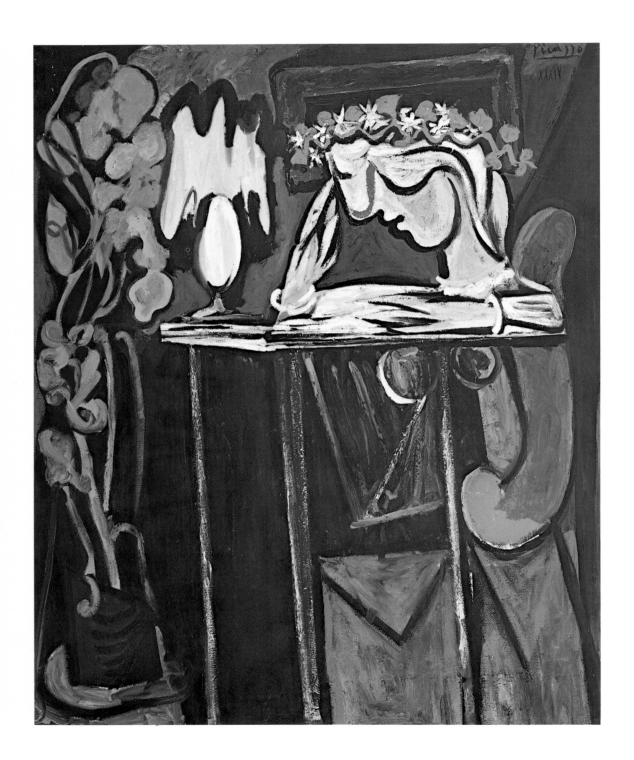

PICASSO. *Girl Reading*, 1934. Oil on canvas, 63⅞ x 51¼". Purchased 1945.

In the early thirties, Picasso's painting became calm and voluptuously curvilinear. In this affectionate rendering of an intimate scene, the girl is given a childlike appearance by her sweet expression and flowered garland, and by the fact that the table is exaggeratedly tall. A near triangle of off-center emphasis is formed by the face and hands. While the sinuous line and the face seen from a double viewpoint recall Braque's nearly contemporary rendering of a similar subject (page 34), there is nothing classical or withdrawn about Picasso's hedonism, as expressed by the full volumes compressed into a close space. The richly entwining plant forms, mellow lamp light, close-up scale and glowing color are in contrast to Braque's static shapes, austere black silhouettes, and detached attitude. *Girl Reading* evokes a moment of peace and well-being, but it is also vibrantly alive.

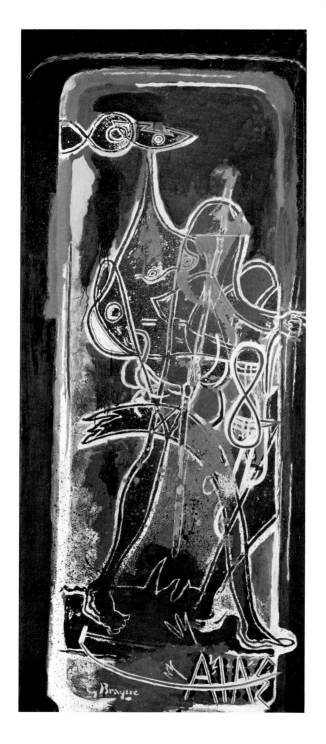

GEORGES BRAQUE. French, 1882-1963. *Ajax* (1949-54). Oil on paper mounted on canvas, 71 x 28½". Purchased 1955.

This striding Trojan warrior, whose adversary is only implied by a leg disappearing at the right, has been variously dated between 1947 and 1955. The image first appears in an engraving from around 1934, and is also preceded by the incised plaster reliefs of 1931, the etchings illustrating Hesiod's *Theogony* (1932-55), the Helios lithographs (1946-47) and various preliminary studies. Inspired by archaic Greek and Etruscan art and then re-interpreted in terms of Braque's own harmoniously graphic cubism, the *Ajax* is also endowed with a more contemporary spontaneity. The firmly delineated black and white double line describing the figure is partially obscured but the surface is further enriched by explosive areas of splattered and splashed color. It is an excellent illustration of Braque's statement: "I like the rule that corrects the emotion; I like the emotion that corrects the rule."

Opposite: BRAQUE. *Seated Nude,* 1926. Pastel, 36⅛ x 25⅜". Purchased 1951.

At the same time that he was constructing such complex and formal still lifes as *The Mantelpiece* (page 32), Braque had also embarked on a series of nudes known as the *Canephors*—majestic giantesses inspired by the ritual basket-bearers of ancient Greece. This is one of several pastel studies for paintings executed between 1922 and 1926. The basic two-dimensionality of the drawn figure is modified but not overcome by the gentle modeling. Its monumentality is expressed by breadth instead of by volume; head and body are widened beyond naturalism, spreading over the picture plane rather than forward into space. This passive, generalized earth goddess exudes both a classical calm and a touch of romantic melancholy.

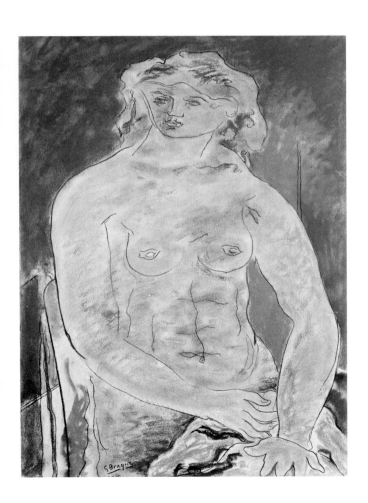

BRAQUE. *The Mantelpiece* (1922). Oil on canvas, 51⅜ x 29⅜".
Purchased 1945. Illustrated page 32.

By 1922, Braque had developed a distinctly personal style out of
the prewar discoveries shared with Picasso. Here a favorite cubist
subject (see also page 22) is treated in a serene, elegant, and cal-
ligraphic manner, though the rectilinear scaffolding and measured
formal relationships of cubism are retained. Pattern is restricted to
logical areas—primarily the patch of wallpaper and the marble fire-
place. Set between these two angular architectural planes, the still
life is flattened and uptilted in order to equate it with its surround-
ings. Guitar, grapes, bottle, dish of pears and finally the music score
labeled "Duo," define a subtly graduated depth. Though the vol-
ume of these objects is denied, their fluid contours, marked by
heavy irregular black line, re-establish their individualities; their
freely rendered shapes are echoed in the ornamental scroll and
carving of the mantelpiece. A subdued but light palette is typical
of the restrained opulence of Braque's postwar work, which was
concerned with the look and the feel of each object as much as
with its abstract nature and placement.

BRAQUE. *Yellow Tablecloth* (1935). Oil on canvas, 45⅛ x 57⅝".
Purchased 1939. Illustrated page 33.

Braque distinguished two types of space between which his art is
balanced, and they are especially evident in the still lifes: "Visual
space separates the objects from each other. Tactile space sepa-
rates us from the objects." The latter is dominant in *The Mantel-
piece* (page 32); the former prevails here, resulting in an airy, open
composition within a well-defined corner expanse. Once again the
still life is described by cubist devices on a tilted plane against a
flat, architectural background, but its pale, luminescent colors and
formal variety make it looser, less intricate and more lively than
the 1922 painting. The sharp triangle of brilliant yellow tablecloth
calls attention to the inverted pyramidal grouping of objects; the
guitar is playfully distorted; the wood grain of the table is deco-
rative but conspicuously unrealistic, unlike the earlier marble pat-
tern. In 1937, this sunny and likeable painting was awarded first
prize at the Carnegie International Exhibition in Pittsburgh.

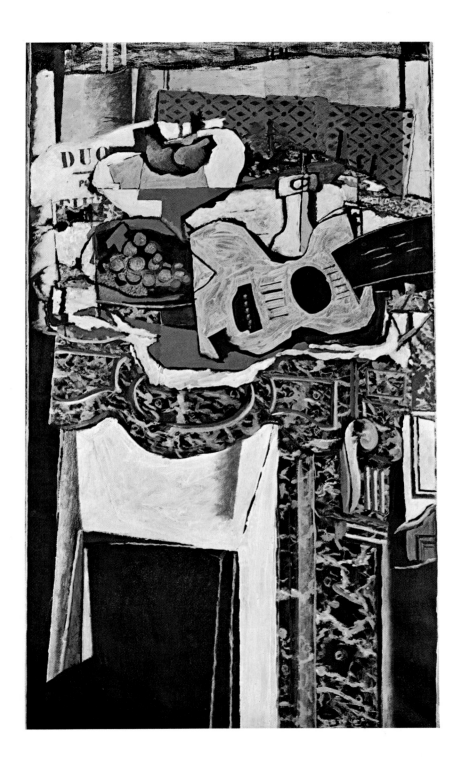

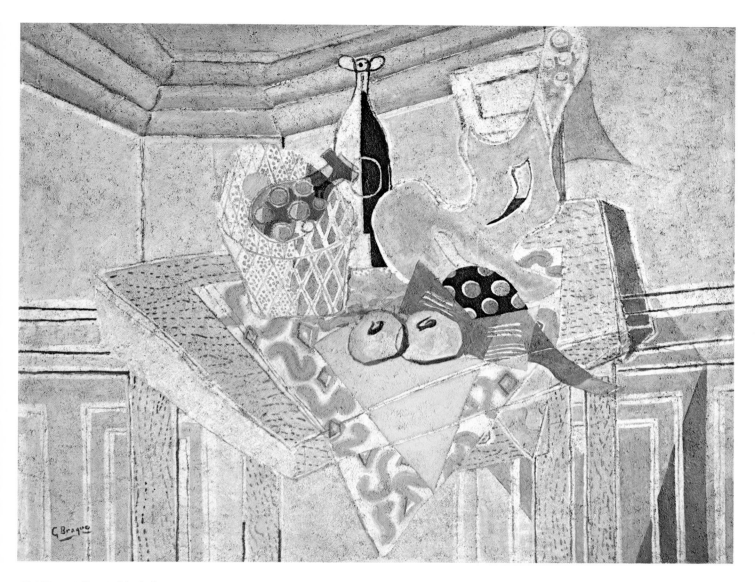

BRAQUE. *Yellow Tablecloth* (1935). Oil on canvas, 45⅛ x 57⅝". See note, page 31.

Opposite: BRAQUE. *The Mantelpiece* (1922). Oil on canvas, 51⅜ x 29⅜". See note, page 31.

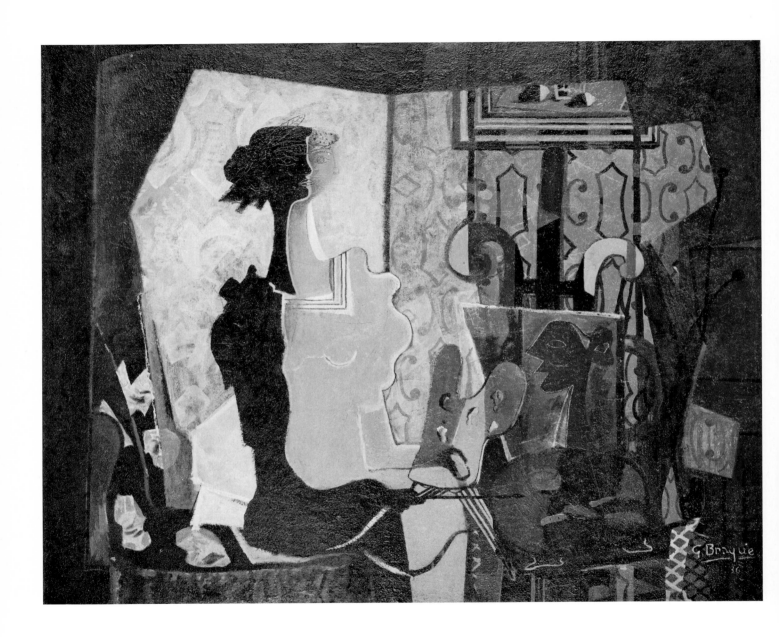

Opposite: BRAQUE. *Woman at an Easel*, 1936. Oil on canvas, 51½ x 63⅞". Purchased 1949.

This figure is almost contemporary with *Yellow Tablecloth* (page 33). It is one of a large series begun in 1936 portraying interiors with seated women engaged in artistic pursuits. The relatively simple and open left side is dominated by a lean black profile which is directly opposed to its "shadow"—a pale, billowing front-face view corresponding to the more ornate and decorative clutter at the right. The "neckline" of this figure's dress is an unmistakably architectural angle reflected by the picture frame above. Curvilinear rhythms moving across the sharp division unite the two sides. The graceful elongated figure has less solidity than the objects with which she is surrounded. As in many of Braque's paintings (see also pages 30 and 35), a dark border or "frame" further stresses a calm detachment from reality. The double viewpoint—a reminder of earlier cubism—suggests a mirror image, and is found in similar scenes by Picasso (see page 28).

BRAQUE. *The Studio* (1949). Oil on canvas, 51½ x 29⅛". Purchased 1950.

In the great series of Studios executed after World War II, Braque turned for subject matter to his own created environment, his private world of objects and works of art—familiar, but juxtaposed by chance. This canvas recalls analytical cubism in its restriction to brown and gray tones, its airless space, interwoven forms, variety of pattern and texture, as well as in the stenciled letters at the lower right. But its breadth, freedom and taste are of a later date. Fundamentally a vertical tower of objects—palette, pitcher, oval picture of a classical head and rectangular window shape—it is subtly offset by the bolder, decorative shapes at upper left and lower right. The white light fixture framed by rich black and the two dabs of bright red and green paint on the palette are brilliant highlights within the somber total scheme.

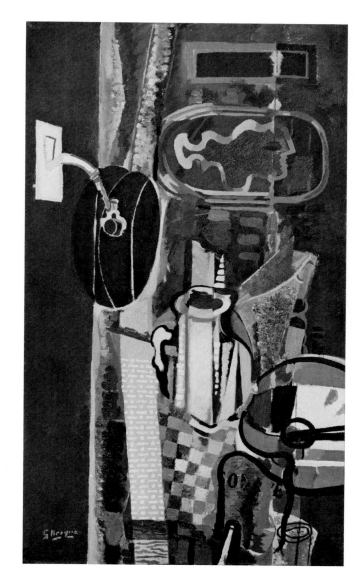

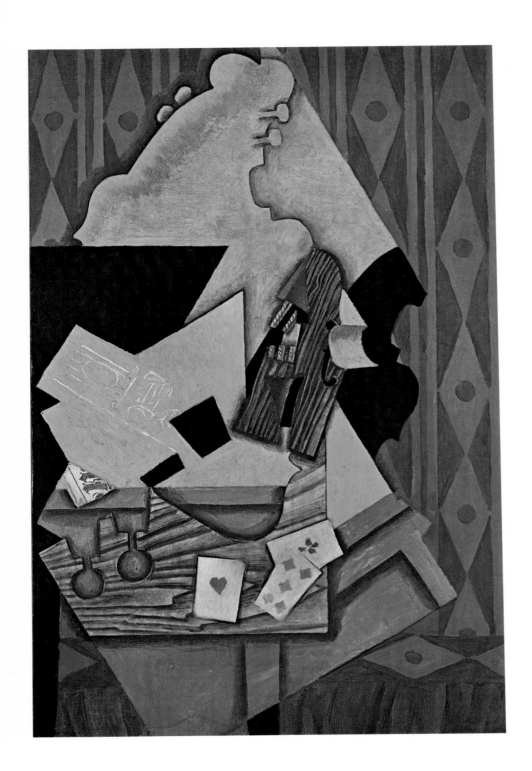

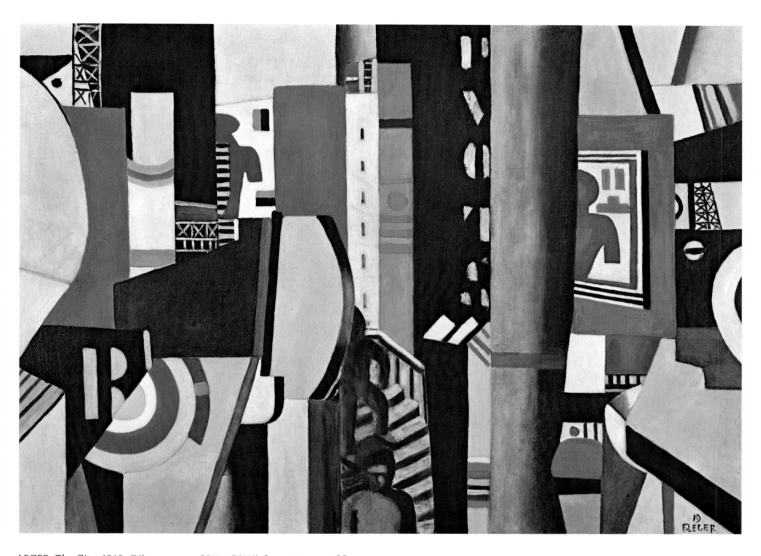

LEGER. *The City,* 1919. Oil on canvas, 38⅛ x 51⅜″. See note, page 38.

Opposite: GRIS. *Still Life with Playing Cards* (1913). Oil on canvas, 39½ x 25¾″. See note, page 38.

JUAN GRIS (José Gonzalez). Spanish, 1887-1927. Worked in Paris. *Still Life with Playing Cards,* (1913). Oil on canvas, 39½ x 25¾". Purchased 1944.

Gris himself compared his art to the "cold" classicism of Ingres and Seurat, and he was considered highly intellectual even within the conceptual framework of cubism. Yet the precision and coherence of this still life do not exclude certain free forms, such as the almost organic guitar which forms the apex of the pyramidal grouping, or the freely rendered blue-tinted area on its left edge and the richness of the red-on-red wallpaper. The colors are translucent and unexpected, ranging from brilliant greens, violets, and blues to bold blacks and a whole scale of browns. Weight and buoyancy are combined in the forms as well; some are planar, others modeled for volume. Mass is concentrated at the left of the composition, but the directional thrusts are to the right. Guitar, newspaper (palely suggested by white lettering on blue), simulated wood, decorative pattern, bright flat color and the denial of deep space are among the trademarks of synthetic cubism included here.

FERNAND LEGER. French, 1881-1955. *The City,* 1919. Oil on canvas, 38⅛ x 51⅜". Purchased 1951.

"Isolated color which had plastic activity of its own, without being bound to an object" is how Léger expressed one of the major elements of this painting. This next to final version of one of his early masterpieces (now in the Philadelphia Museum) was preceded by myriad studies, often representing only minute changes in composition. The column form at the right was ultimately changed to a banded diagonal, the stenciled letters to its left became stronger, a zig-zag replaced the two diagonals in the upper right corner, and so on. Step by step Léger evolved a complex symphony in brilliant, dissonant color and urban-derived form. The flat, fragmented shapes are suggestive rather than figurative, yet it is a recognizable depiction of man in the modern city, surrounded by a bewildering environment of industrialization and progress which threatens to dehumanize its inhabitants. The two shadowy men are less real than the painted mannequins. "For me," said Léger, "the human body has no more importance than keys or bicycles."

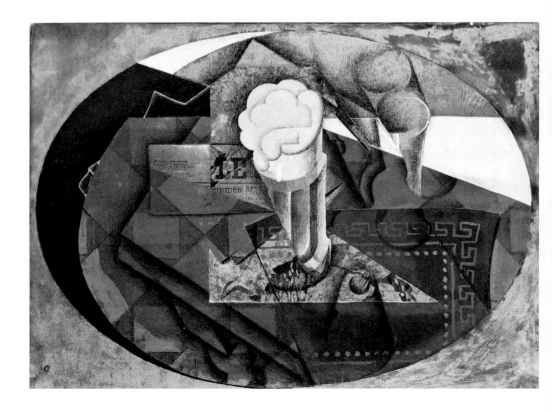

LEGER. *Woman with Cat,* 1921. Oil on canvas, 51¼ x 35¼". Purchased 1958.

This woman, whose massive machine-like limbs are dully gleaming like the "steel with a thousand reflections" Léger had found so attractive in big guns, is typical of the increasing impersonalism of his art. She is static and faceless against a field of erratic patterns and solids. The whole canvas is low-keyed, almost monochrome except for the brilliantly checkered yellow and black chair. The woman's legs are a warmer, more earthy tone—a concession to her humanity. "I search for the form and I find the rhythm...I always depart from the object and I never produce sentiment." Sacrificing emotional appeal on the altar of order, Léger became a master of pictorial design.

Opposite: GRIS. *Still Life with Glass of Beer* (1914). Collage, oil, charcoal, pencil and ink on canvas, 21¼ x 28¾". Purchased 1949.

In 1914, collage became a major element in Gris' refinement and control of cubist technique. Here most of the surface is covered by pasted papers—wood-grained, marbleized, newsprinted or just shaded in charcoal—which stress the presence of a flat picture plane. These materials are not imitative of reality, and were intended, said Gris, as "simple facts, *but created by the mind,...* one of the justifications for a new form in space." This new form was achieved by the fragmentation and faceting of planes into angular slivers, among which a few hard and tangible circular shapes stand out as clues to recognition of glasses or foam on the beer. Their curves are echoed by the oval format. A single cool, dark green in the tablecloth relieves the low-keyed chorus of brownish tones (some of which are due to age), and the result of this economy is a complex creation that owes little to nature.

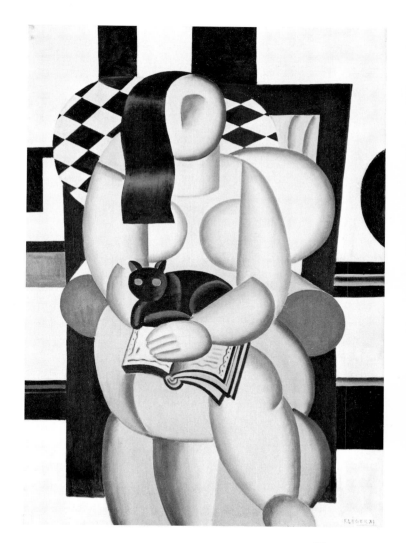

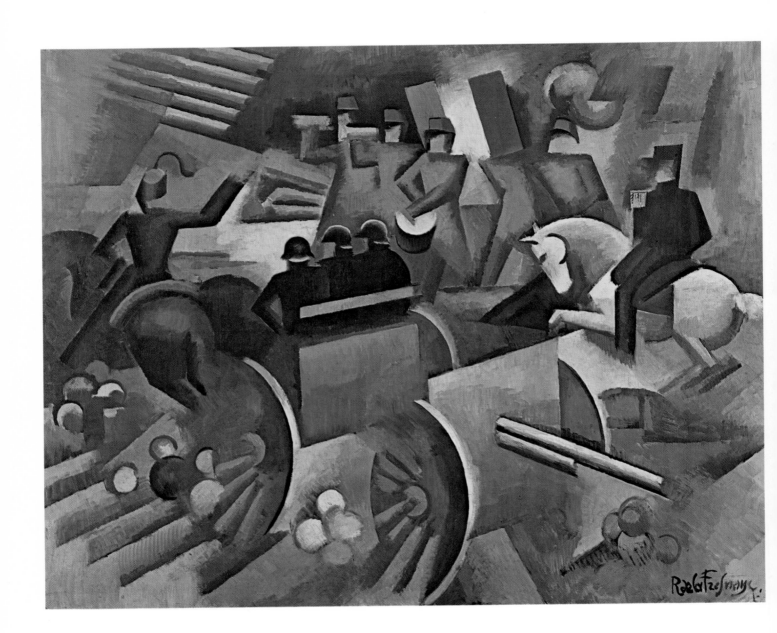

Opposite: ROGER de LA FRESNAYE. French, 1885-1925. *Artillery*, 1911. Oil on canvas, 51¼ x 62¾″. Purchased 1943.

Lucidly, even rigorously organized, with an eye to classical distinction of individual form, this is an early example of La Fresnaye's cubism, which was to become less literal in the next three years and reach its climax in the great *Conquest of the Air*. Patriotism was then a favorite theme of his, and this presents an ideal of war —French flags waving, bands playing, cannons rolling, horses prancing. All nobility and martial glory, it was executed before the artist experienced the horrors of actual battle, where he received wounds that made him an invalid and finally took his life at the age of forty. This is cubism in the traditional grand manner. Clear diagonals define the compact mass of men, horses and guns surging to the upper left. The flatter and more abstract cubist planes at the edges echo and prolong the enclosed movement. La Fresnaye had traveled in Italy in 1910, and the somber color pierced by flashes of red, blue or gold, chiaroscuro concentrated on the geometric essence of each volume and curves played against angles indicate the influence of Uccello as well as of Delacroix and Cézanne.

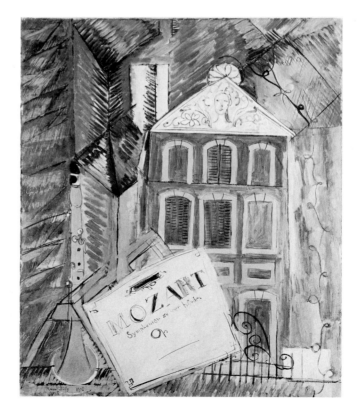

RAOUL DUFY. French, 1877-1953. *Mozart's House in Salzburg*, 1916. Oil on canvas, 31⅞ x 25⅝″. Purchased 1944.

Dufy had a lifelong attachment to musical subjects, among which references to Mozart's rococo forms often appeared. "My eyes were made to efface that which is ugly," he once said, and his art finally reflected his involvement with fashion and theatre design in its acceptance of the conventionally pretty. This painting represents a transitional period in which the remnants of Dufy's fauve and cubist styles provide a solid skeleton of angular form and bright color on which to superimpose the calligraphic motifs that eventually comprised his mature style. The flat and decorative central area contrasts with the weightier cubist periphery. House, horn and score are drawn, rather than painted, as are the curling lines of the sculptured pediment, ironwork gate and vine at the right. They are not fragmented and integrated into the whole as they would have been in a cubist work, but are separated and pulled forward as such objects often were in French baroque illustration and ornament.

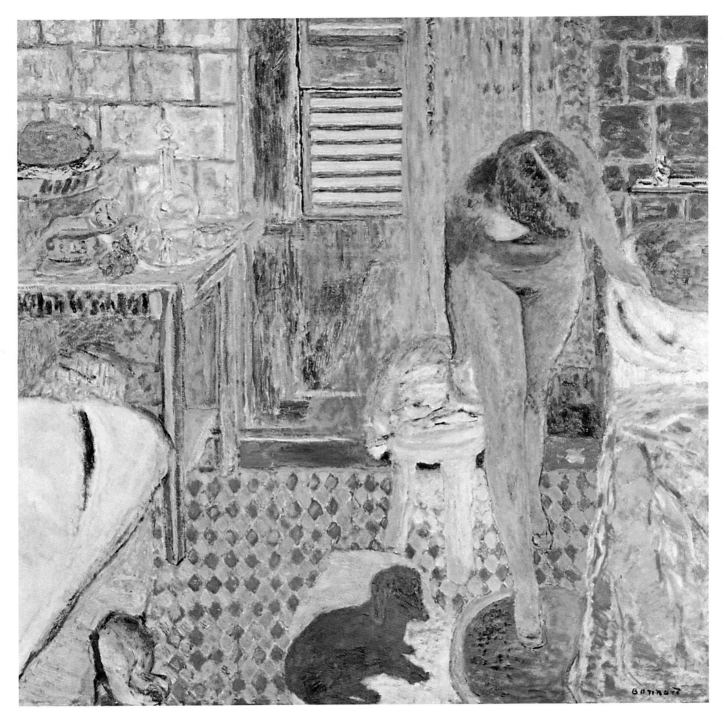

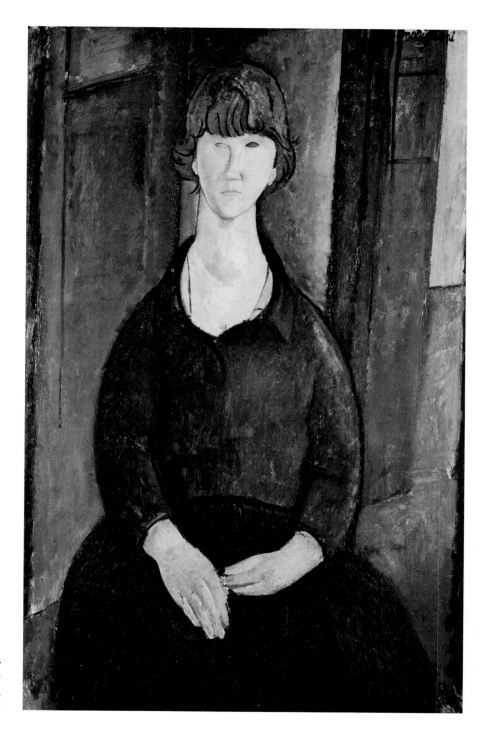

Opposite: BONNARD. *Nude in Bathroom* (1932).
Oil on canvas, 47⅝ x 46½″. See note, page 44.
MODIGLIANI. *Flower Vendor* (1917). Oil on canvas,
45⅞ x 28⅞″. See note, page 44.

43

PIERRE BONNARD. French, 1867-1947. *Nude in Bathroom* (1932). Oil on canvas, 47⅝ x 46½". Purchased 1947.

This 1932 oil incorporates an intimate, poetic mood and an off-center "Japanese" composition which is experienced at first glance as a field of sun-struck color rather than as a specific scene. Bonnard has set curving foreground forms in shallow space against a rectilinear background, but the logic of the painting's structure is disguised by shimmering, overlapping planes and indistinct patterns, by close-valued, intense hues that blur edges and textural differences and unite areas of warmth and coolness to produce a single surfaced, tapestry-like effect related to Persian painting. Whereas Bonnard's light-filled color and technique emerged from impressionism, at the other extreme it seemed to anticipate abstract expressionism, particularly in those later works where paint quality and surface gained more and more independence from form. The nude figure—probably the artist's wife, who has been described as "self-absorbed" and "moving on tiptoe"—is out of focus, as though accidentally caught by a camera aimed at something else; she is remote and passive, her bowed head stressing the aura of privacy and the domesticated hedonism that pervades all of Bonnard's art.

AMEDEO MODIGLIANI. Italian, 1884-1920. Worked in France. *Flower Vendor* (1917). Oil on canvas, 45⅞ x 28⅞". Purchased 1950.

Three years before his untimely death, Modigliani painted this calmly curving portrait of a Parisian flower-seller. He usually preferred subjects from the working classes; the simplicity, directness and at the same time atavistic elegance of his style lent itself to portraits. As in other paintings discussed here, the rounded volumes of the figure are placed before a rectangular ground; further contrast is provided by the dark, cool shade of the girl's dress and the rich, earthy browns and reds around her. The figure is a flowing quasi-silhouette—immobile, elongated, with the frontality, pyramidal form and unblinking gaze of a medieval madonna. Another element from traditional portraiture is the two hands that stand out starkly from the dress and repeat the oval forms of face and neckline. Straightforwardly realistic, this painting is nonetheless unmistakably modern in its roughly rendered surface and strong color. The columnar neck, oval face, eyes, mouth and triangular nose are modeled on African sculpture, like Picasso's earlier heads (see page 17), but with very different results.

Opposite: GIORGIO de CHIRICO. Italian, born Greece 1888. Worked in Paris. *Ariadne,* 1913. Oil on canvas, 53⅜ x 71". Purchased 1955.

Despite de Chirico's profound influence on the later surrealist movement, he stands alone in contemporary art by virtue of his enigmatic fusion of past and present, classicism and romanticism. The emphasis on the subconscious sources in his art is a twentieth-century manifestation, but these sources are expressed in terms of a great nostalgia for the past, evident in de Chirico's iconography, technique, and even his radically altered perspectives, which recall the early Renaissance. The Ariadne shown here is the artist's variant on a Roman copy after a Hellenistic statue, but it lacks the perfection of the Antique, and is, in fact, more crudely rendered than anything else in the picture. Like the exaggeratedly diminished arcade, tomb-like medieval tower, sharply shadowed empty piazza, distant train and ship, and the pellucid light, the sleeping figure is one of the habitual props in de Chirico's dream theater, each of which has its roots in childhood experience or obsessive memory. The incongruity of the architectural elements is compounded by the locomotive, whose smoke is a motionless volume suggesting the reclining Ariadne itself. A curiously festive note is added to the gloomy palette by the tiny banners floating from tower and ship, but nothing is allowed to detract from the silence and sense of the infinite which are at the heart of metaphysical painting.

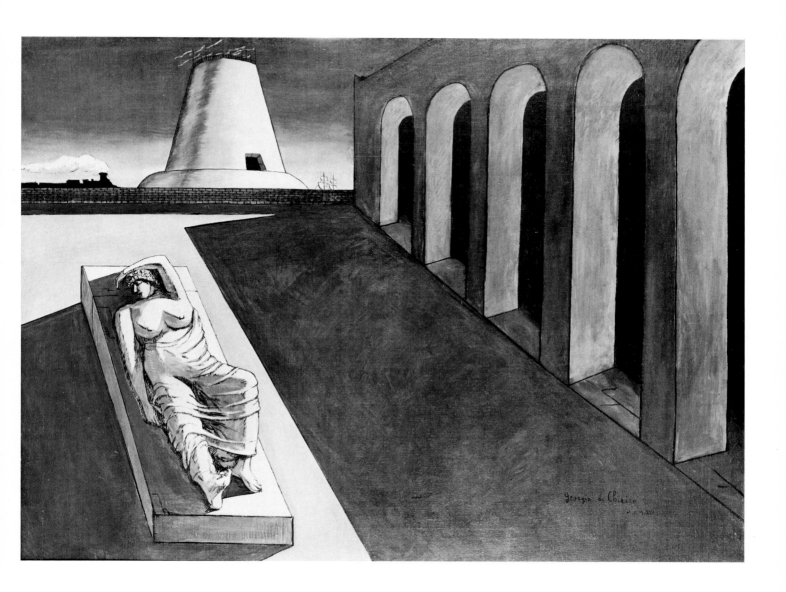

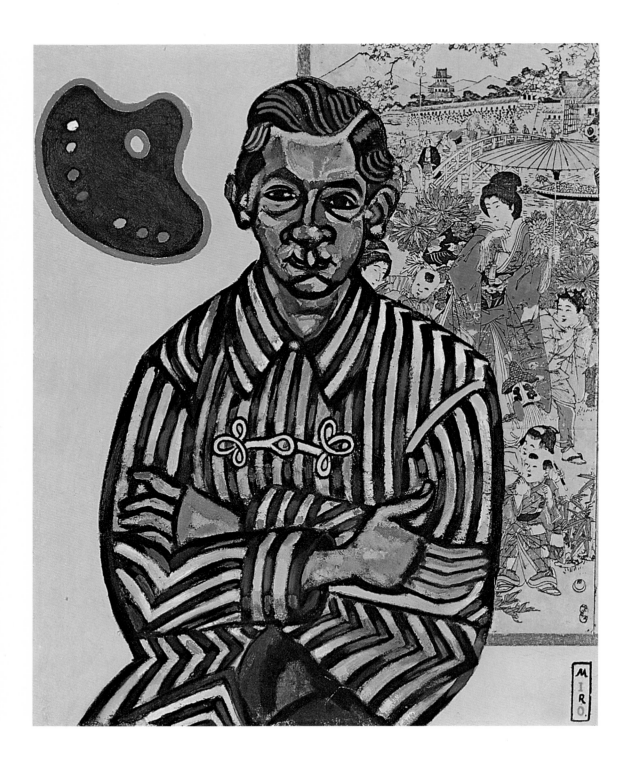

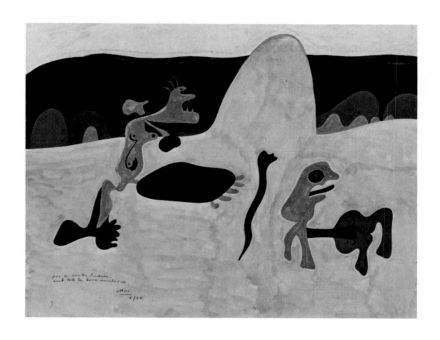

MIRO. *Personage, Animals and Mountains,* 1935. Tempera on paper, 13⅛ x 16⅝". Purchased 1955.

Opposite: JOAN MIRO. Spanish, born 1893. Worked in Paris. *Portrait of E. C. Ricart* (1917). Oil and pasted paper on canvas, 32¼ x 25⅞". Purchased 1950.

This early portrait of a Catalan artist who was one of Miró's closest friends during his student days in Barcelona, and with whom he shared his first studio, recalls some of van Gogh's portraits in color, composition, and use of the Japanese print. But where the post-impressionist would have reproduced the print in paint, the post-cubist made a collage by gluing the original to the surface of the canvas, creating a sharp contrast between its delicacy and pale colors and the deliberately crude treatment, weighty paint quality and acrid hues of the rest of the painting. While the compartmented vertical signature as well as the shallow space and interest in pattern carry through the Japanese theme, the unconventional use of color, sculptural planes of the face, stylized jacket and hair, awkward non-realistic hands and the free-form palette on the wall distinctly belong to twentieth-century European art, and predict aspects of Miró's mature style. The result is direct characterization within a vigorously abstract framework.

Here is a parade of whimsical creatures resembling the fantastic hybrids of Hieronymus Bosch, but Miró's figures are more barbaric and direct; the one on the left evokes a hulking caveman with a club over his shoulder, and there is something equally prehistoric about the stark mountain landscape—probably derived from that of Montroig, in Catalonia, where the artist was spending his last summer before the Spanish Civil War. The threatening conjunction of yellow, orange, purple and black, and the grimly determined advance of the near-monsters (reflected by the incline of the central hill and then countered by the variety of rhythm, shape and line in the foreground) convey a spirit of impending disaster, tempered, but not diminished, by an inherently decorative impulse.

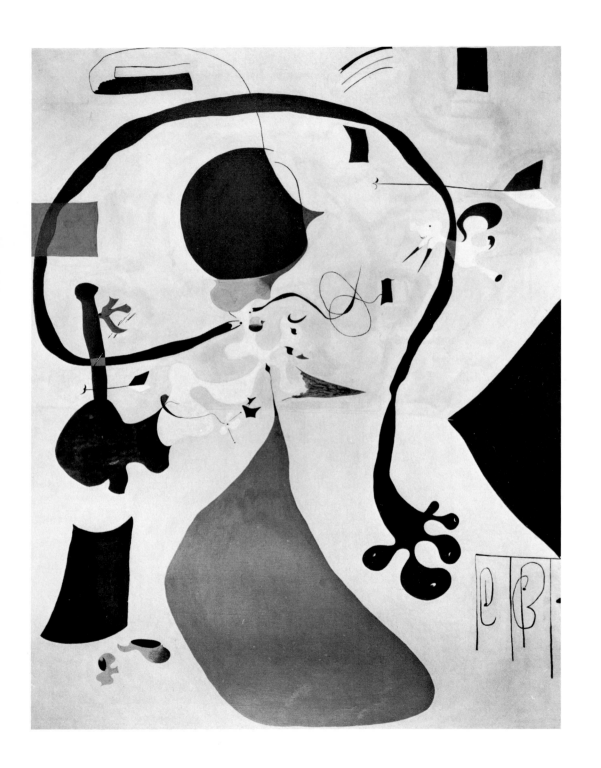

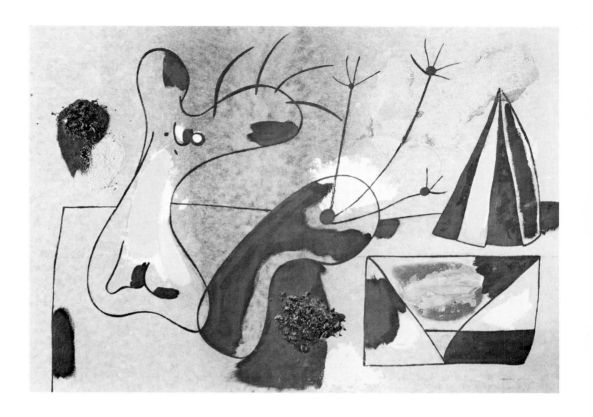

Opposite: MIRO. *Dutch Interior* (1928). Oil on canvas, 50¾ x 37⅞". Purchased 1950.

In 1928, Miró went to Holland for a brief visit and brought back postcards of works seen in the museums, from which he painted a series of *Dutch Interiors* paraphrasing seventeenth-century genre scenes. While the origins of two of these are identified, a definitive source for this one has not yet been established, and it may be an amalgam of motifs from several paintings. The central figure seems to be a woman holding a book in one threadlike hand; the rectangles in the background could be paintings or windows, and the two small shapes in the left corner, wooden shoes. The free form at the left may be a musical instrument. Whatever the subject, Miró has transformed it into a lively surrealist abstraction by changes of scale and pictorial emphasis, and by translation into the biomorphic forms, playful rhythms and dispersed calligraphic notes that constitute his unique style. For another modern interpretation of a seventeenth-century Dutch painting, see page 13.

MIRO. *Painting*, 1936. Oil on masonite, 31 x 42⅝". Purchased 1950. The Art Institute of Chicago. Gift of Mr. and Mrs. Samuel A. Marx.

In 1936, in a series of rapidly executed paintings on masonite, Miró dispensed with all figurative references, and object was replaced by symbol. He has always insisted that for him "a form is never something abstract; it is always a sign of something." Nevertheless, the emphasis here is on a ragged surface rhythm in which flat drawn shapes are contradicted rather than fulfilled by rough patches of color and texture. These are among his most expressionistic works. In them he seems to have been less concerned with formal organization than with the tactile qualities of the paint itself and the gestures implicit in the act of painting.

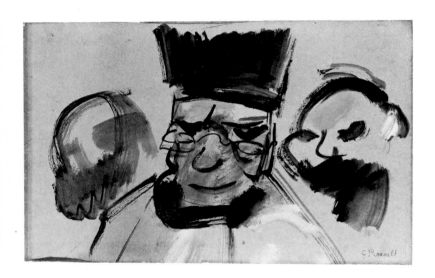

GEORGES ROUAULT. French, 1871-1958. Sketch for *The Three Judges* (c. 1907). Oil and wash on red paper, 14⅝ x 22⅝". Purchased 1941.

The first ten years or so of Rouault's mature art were concerned with social protest, and one of his major themes was the injustice and corruption of French law. A drawing of a judge dated 1901 seems to mark the beginning of this motif, and in 1907, like his great predecessor Daumier, Rouault began to frequent the courts and sketch the proceedings. Ritual subjects like trials, weddings, lectures or banquets were often presented in such a tripartite frontal composition. Rouault used it consistently on the three judges theme, to which he returned again and again over the years. This rapidly brushed sketch is one of the earliest examples. The central face is exaggerated but not humorous; the other two, despite their lack of definition, are equally caustic.

Opposite: ROUAULT. *The Three Judges,* 1928. Oil and gouache on paper mounted on cardboard, 29½ x 21⅝". Purchased 1943. The Art Institute of Chicago. Gift of Mr. and Mrs. Samuel A. Marx.

"The reason I gave my judges such woeful faces," said Rouault, "was doubtless that I expressed the anguish I myself feel when I see one human obliged to judge another." By 1928, the sinister trio had become more compact and tightly knit. The three heads—two in profile now—are molded into a single vertical form compartmented by the heavy black contour lines derived from the artist's early work in stained glass. While the faces are still travesties, there is an added solemnity that emphasizes the tragic rather than the satirical side of the subject. Yet at the same time, the impression is conveyed that this same solemnity is a travesty in itself. The judges are taking themselves seriously, but the quality of their justice has not improved.

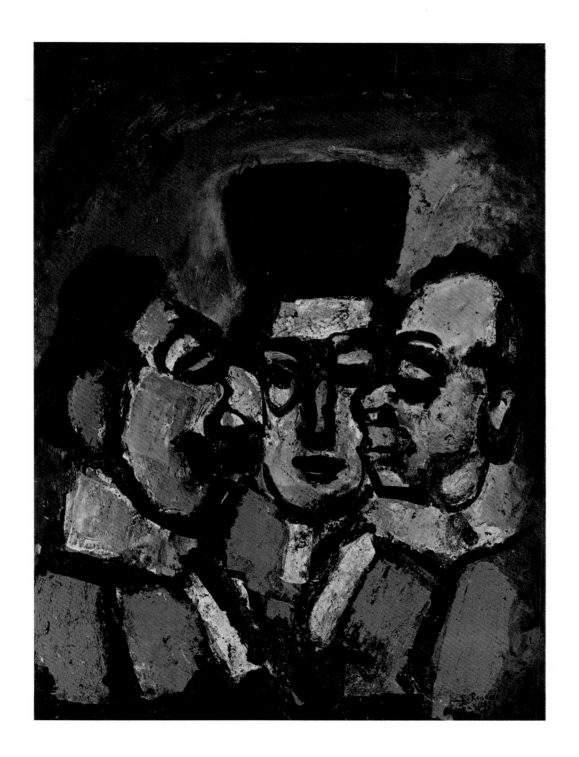

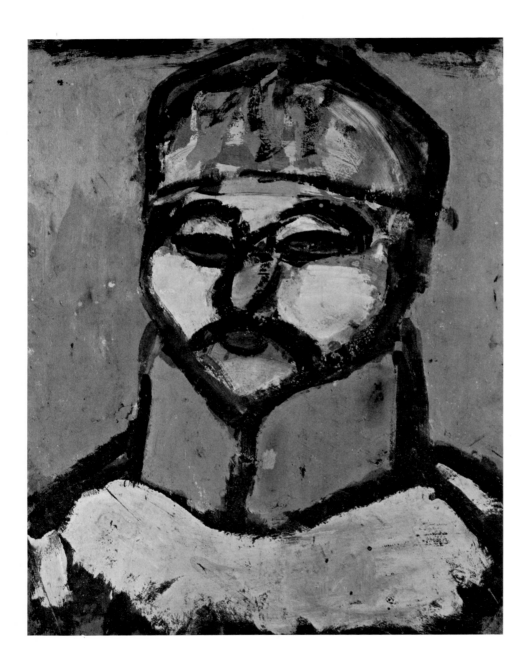

52

Opposite: ROUAULT. *King Ubu,* 1916 (recto). Tempera on cardboard, 30 x 22⅞". Purchased 1954.

ROUAULT *Palace of King Ubu,* 1916 (verso). Tempera on cardboard, 30 x 22⅞". Purchased 1954.

"The grotesque and the tragic are juxtaposed in my work, but aren't they also inseparable in life?" No better subject could have been found for Rouault's brush than Alfred Jarry's great satirical epic, *Ubu Roi,* with its monstrous, absurd and very modern anti-hero. After Jarry's death Rouault was commissioned by the art-dealer Vollard to illustrate a "reincarnation" of Ubu written by Vollard himself. The prints were not finished until 1928, nor published until 1932, but Rouault began studies of the subject in 1916. These two pictures are, therefore, among the first essays, and do not specifically relate to any of the completed prints. Ubu is depicted here in a manner unlike that usually employed by Rouault or by anyone else. Solid, almost rectangular in form, filling the sheet from top to bottom, this is the face of a cruel oriental potentate, more imposing than ridiculous with its blank eyes and medieval frontality. The eastern motif is continued in the onion-domed palace on the reverse side, which is rather oddly proportioned in accord with the character of its mythical inhabitant.

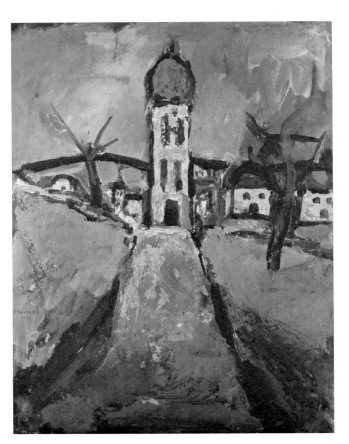

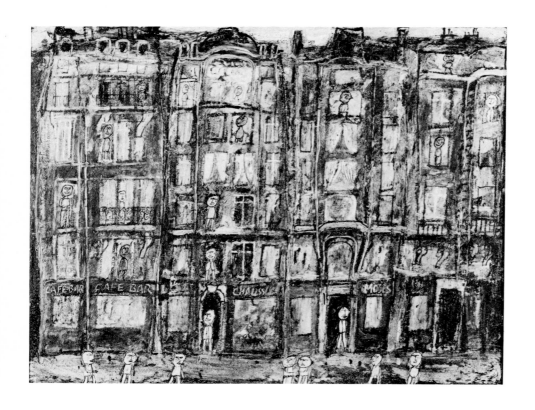

JEAN DUBUFFET. French, born 1901. *Building Facades, Paris,* 1946. Oil, sand and charcoal on canvas, 44½ x 57½". Purchased 1947.

Although he returned to primitive sources for his inspiration like the cubists and the surrealists, Dubuffet attempted to divest them of all exoticism in order to stress direct experience and return art to its true role as a "free celebration...whose only terrain is rapture and delirium." In conscious revolt against the overtasteful and decadent art prevalent in Paris in the forties, he has utilized awkward stick figures, rough techniques and denial of perspective to depict the swarming multiplicity and anonymity of modern city life. His own collection of *art brut* (crude or "raw" art) includes work from primitive cultures, and by the untaught, the insane and children, but although his style may stem from the unaffected naiveté of children's art, no six-year-old could master that subtle balance between savage satire and richly humorous "innocence" which has made Dubuffet one of the most sophisticated and influential artists of the postwar period.

Opposite: CHAIM SOUTINE. French, born Lithuania, 1894-1943. *Man in a Green Coat* (c. 1921). Oil on canvas, 35 x 21⅞". Purchased 1950.

Soutine spent his most productive, and probably greatest, years—from 1919 to 1922—in the little town of Céret in the French Pyrenees, where he created a new mode of expressionism. Freedom of paint handling was equaled only by the emotional intensity of the twisting forms, perhaps partially inspired by El Greco. Several portraits exist of the man depicted here, but individual characterization is forgone for overall mood, specific textures for a single unified surface that is neither cloth nor flesh, but a substantial, tangible amalgam of both with the quality of the paint itself. As in Soutine's landscapes, movement rather than form is paramount. Sinuous distortion, continuous brushstroke, and rhythmic flow, in fact, liken the figure to a mountain. An earthy contour against a flaming "sky," it climbs steeply to the left, the extended shoulder moving uninterruptedly into the long face.

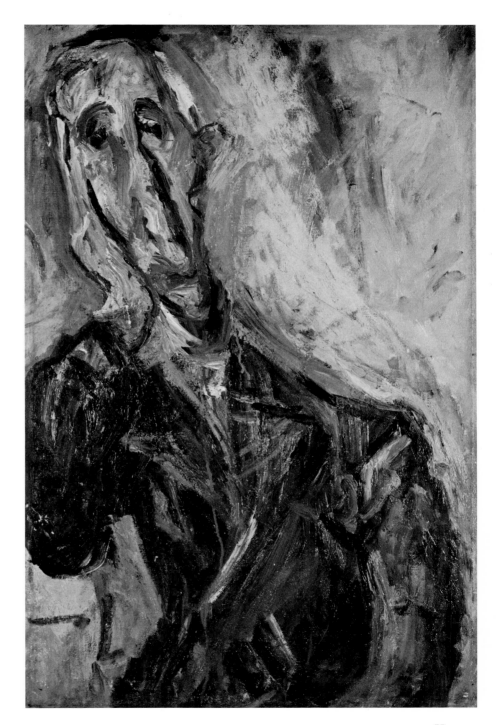

# INDEX OF ARTISTS AND WORKS

SCHEDULE OF THE EXHIBITION

The Museum of Modern Art, New York:
   November 1, 1965-January 2, 1966

The Art Institute of Chicago:
   February 11-March 27, 1966

City Art Museum of St. Louis:
   April 26-June 13, 1966

Museo de Arte Moderno, Mexico City:
   July 2-August 7, 1966

San Francisco Museum of Art:
   September 2-October 2, 1966

Cover: *The Moroccans*, (1916). Oil on canvas, 71⅜ x 110″.
The Museum of Modern Art, New York.
Gift of Mr. and Mrs. Samuel A. Marx.